Dedicated to
Donnie + Alfie

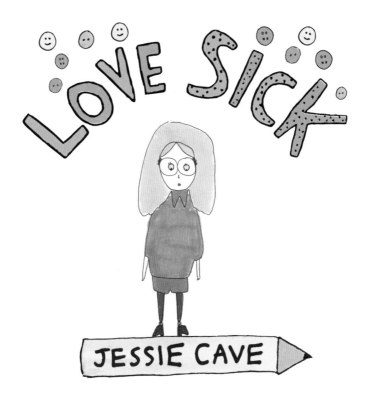

LOVE SICK

JESSIE CAVE

EBURY
PRESS

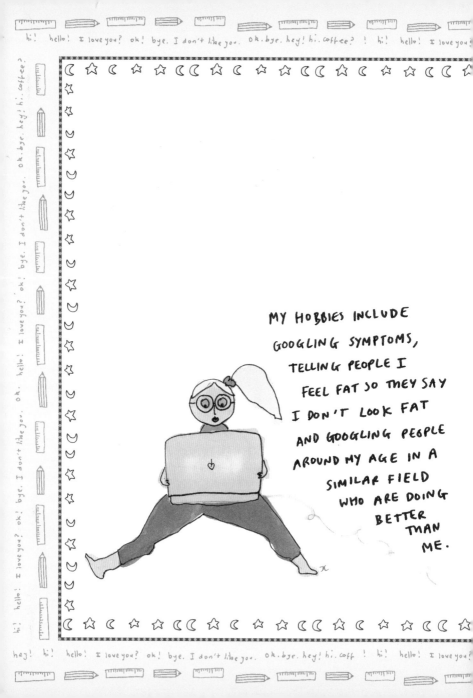

A B O U T

JESSIE CAVE IS AN ACTRESS,
WRITER AND DOODLER.
SHE DOES A DOODLE A DAY
ONLINE AND HAS DONE SO
FOR FOUR YEARS NOW.
LOVESICK IS A COLLECTION OF
HER MOST NEUROTIC DRAWINGS
ESPECIALLY FOR PEOPLE WHO
MIGHT BE WAITING FOR A
TEXT.

♡ XXX ♡

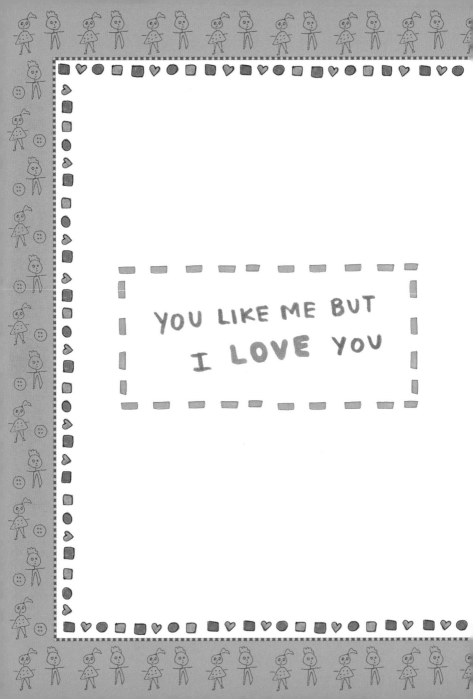

YOU LIKE ME BUT
I LOVE YOU

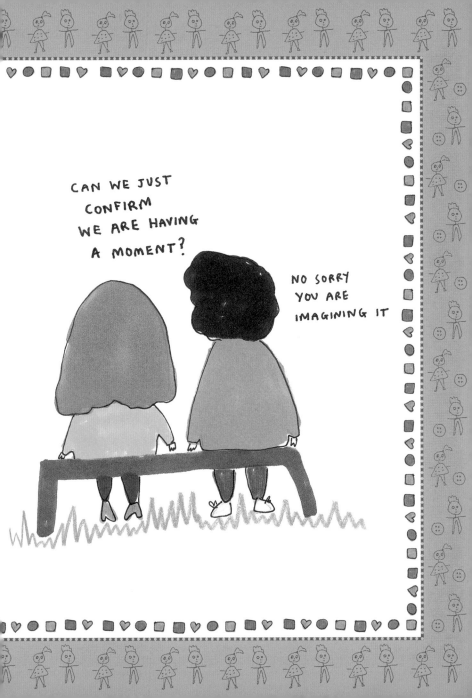

X O X O X O X O X O X O X O X O X O X O X O

UMMM - I'M
PRETTY PISSED OFF.
YOU LOOK
NOTHING
LIKE YOUR
PROFILE PICTURE -

I KNOW.
I'M WAY BETTER
IN REAL LIFE.
I'M SORRY.

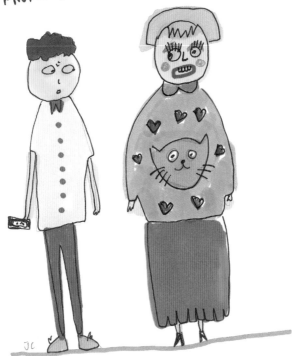

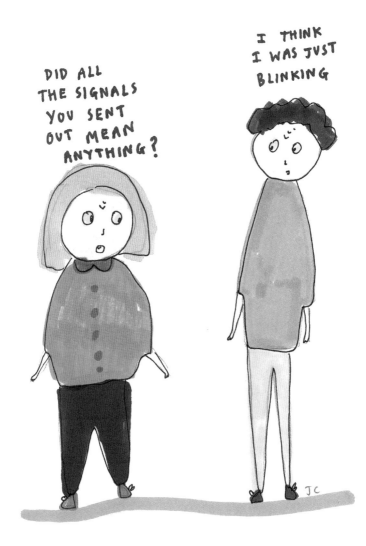

my boyfriend is bad
at communication

is he your
boyfriend?

well the last text said
he
was

That was
400 days ago.

I FEEL GOOD. HOW ABOUT SENDING HIM A FUN SPONTANEOUS NON-THREATENING TEXT

SEND! HE HAS A SENSE OF HUMOUR. HE'LL LOVE IT! I'M FUNNY!

MAYBE IT WAS SLIGHTLY THREATENING MAYBE HE DOESN'T REALISE I'M FUNNY YET. I FEEL SICK. WHAT AM I DOING WITH MY LIFE?

HOW CAN I DE-SEND? MUM?

IT'S FUNNY
BECAUSE USUALLY
I ONLY GO OUT WITH
SKINNY GIRLS!

THAT IS FUNNY.
I USUALLY ONLY
GO OUT WITH
DICKS.

WHY DIDN'T YOU CALL ME?

BECAUSE I WAS BUSY NOT WANTING TO CALL YOU.

No the flat was furnished. Do you want to leave now?

WOW! COOL! YOU PLAY GUITAR?

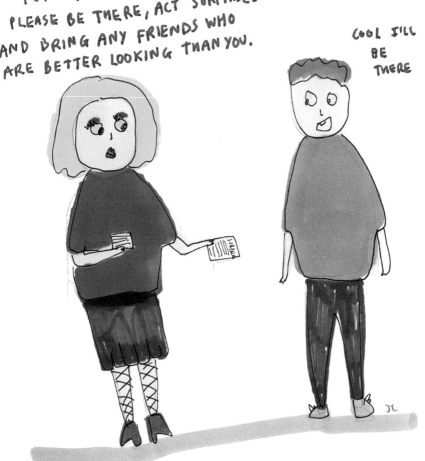

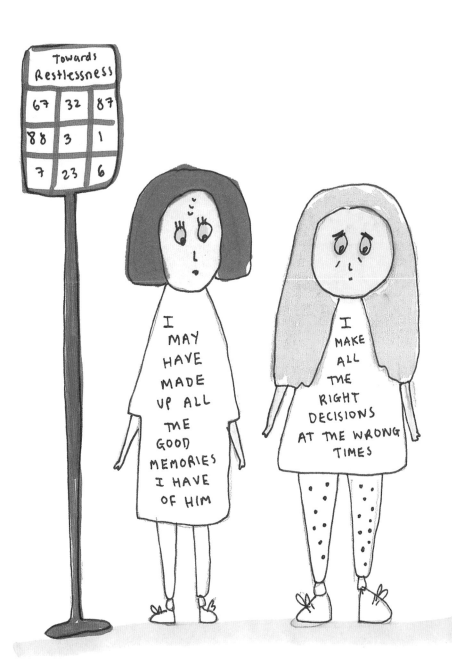

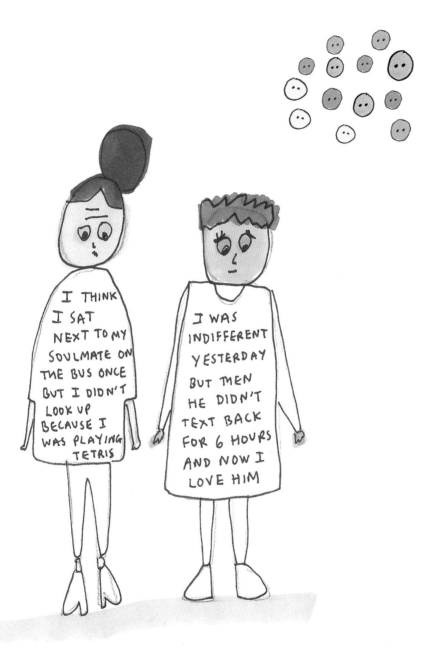

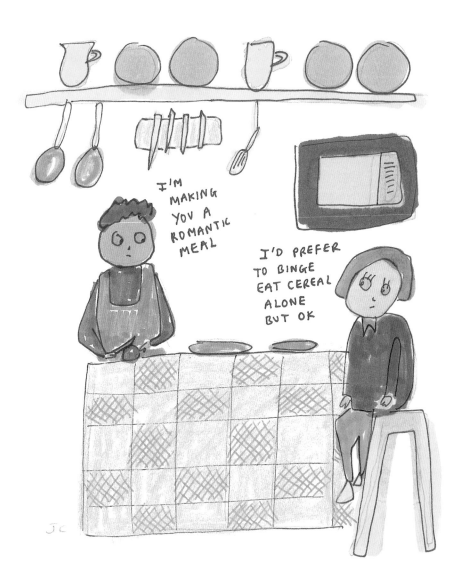

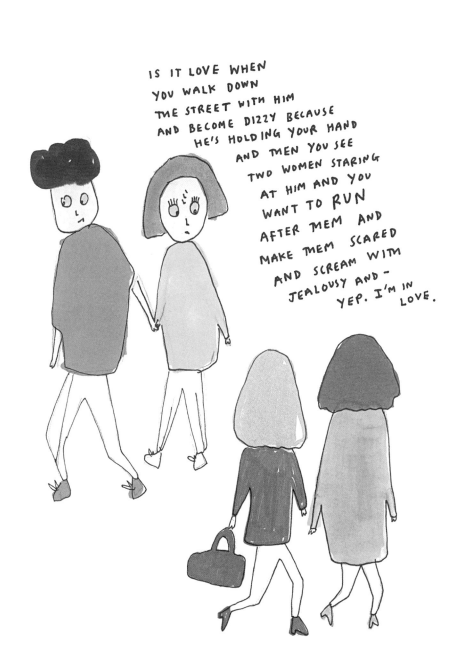

IS IT LOVE WHEN YOU WALK DOWN THE STREET WITH HIM AND BECOME DIZZY BECAUSE HE'S HOLDING YOUR HAND AND THEN YOU SEE TWO WOMEN STARING AT HIM AND YOU WANT TO RUN AFTER THEM AND MAKE THEM SCARED AND SCREAM WITH JEALOUSY AND — YEP. I'M IN LOVE.

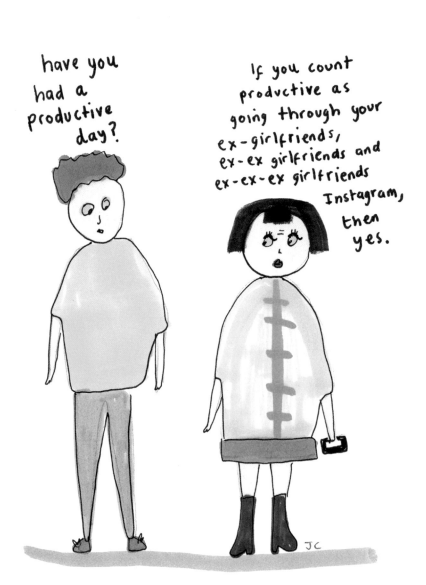

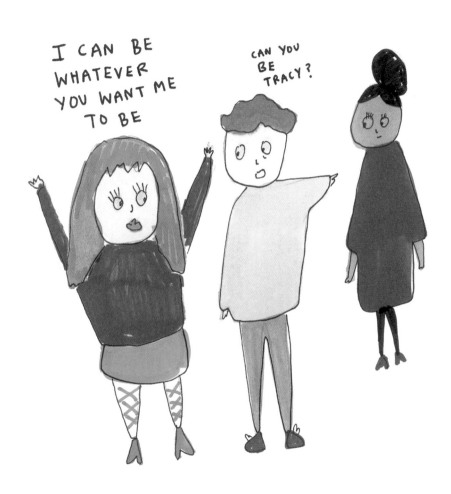

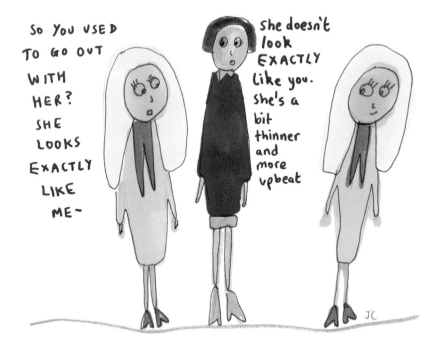

I WORRY THAT
EVERYONE ELSE
BORES ME AND
YOU ARE THE ONLY
GOOD THING I HAVE
AND ONE DAY YOU
WILL DIE AND
 I'LL HAVE
 NOTHING

I THINK
YOU'LL DIE
BEFORE ME
SO DON'T
WORRY
SO MUCH

△○▽○△○▽○△○△○△○▽○△○▽○△○

YOUR EX IS AMAZING.
LET'S KEEP TALKING
ABOUT HOW
AMAZING SHE
IS AND HOW MUCH
SHE STILL MEANS
TO YOU. HOW
COOL AND FUN
AND THIN SHE
IS. HOW GOOD
SHE IS WITH
ANIMALS AND
RECEIPTS. HOW
MUCH YOU LOVED
HER AND —

I can't
tell if
you are
being
sarcastic
but OK!
This is fun.
She
also had
amazing
breasts.

MAYBE
I SHOULDN'T
HAVE WORN
THIS SKIRT
AND
MAYBE
I KIND
OF
REGRET
TALKING
ABOUT THE
FILM
"FREEWILLY"
WHEN HE WANTED
TO TALK ABOUT
FREE WILL AND
DETERMINISM

I wanted
to wear
this dress
when he
proposed
but
I COULDN'T
work out when
he was going to
propose so I
just wore
it all the
time but

he never
proposed

Class Ticket type Adult Child
STD OFF-PEAK R ONE NIL RTN

Start Date Number
6·MCH·14 61896 500618921 *

I HAVE
TWO HOURS
AND FIVE
MINUTES
TO MAKE
AN
IMPACT

VALID ONLY WITH TRAVEL TICKET

Price
£0·00

TRAVEL
50061892

Date of issue
16·MCH·14

Number
61897

Pass·grs
ONE

Class
STD SEAT

Ticket type

From
LONDON EUSTON *

OWNER'S COPY

MANCHESTER STNS

To
LONDON TERMINALS

Valid until
15·APR·14

Route
ANY PERMITTED

Price
£79·7HOURS ON

Validity
AS ADVERTISED

2-PART RETUR SERVA

MRS M TODD

ToD CTR 1LJG3C3N·6701 Printed 12:45 on16·MCH· Printed 12:45

LLECTION RECEIPT

To
MANCHESTER

Number(s) Value
61896-61897 £79.

Date & Time
14-MCH-14 18:30 500618927

Coach Seats
D 04

0036

NOT VALID FOR TI

TD OFF-PEAK R ONE NIL OUT

1CH·14

14·MCH·14 61896

Start Date Number

Valid at
13:17

Valid until Price
ERMINALS 16·MCH·14 £79·10W

Route Validity 91
ER STNS ANY PERMITTED AS ADVERTISED

2-PART RETURN RE

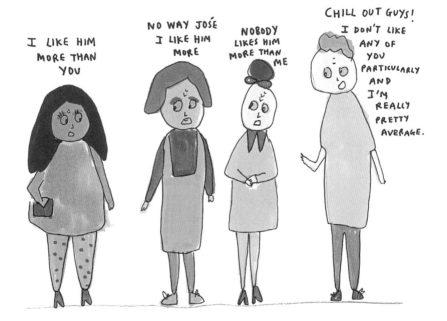

I LIKE HIM MORE THAN YOU

NO WAY JOSÉ I LIKE HIM MORE

NOBODY LIKES HIM MORE THAN ME

CHILL OUT GUYS! I DON'T LIKE ANY OF YOU PARTICULARLY AND I'M REALLY PRETTY AVERAGE.

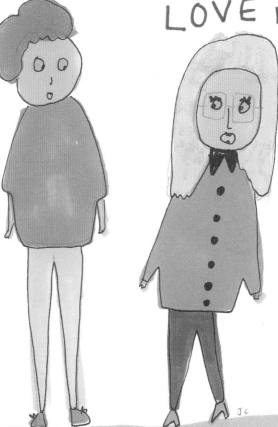

FRIENDS
FOREVER

TERMS + CONDITIONS APPLY

I'M WORRIED
MY FRIENDS ARE
IDIOTS

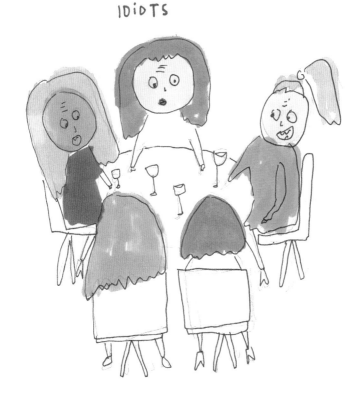

BITCH YOU
MAY BE MORE
FLEXIBLE BUT
YOUR NEGATIVE
ENERGY IS PALPABLE

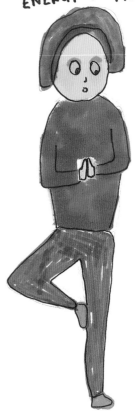
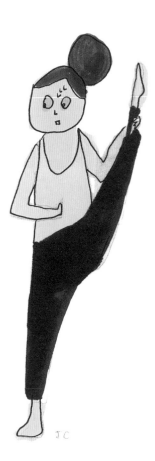

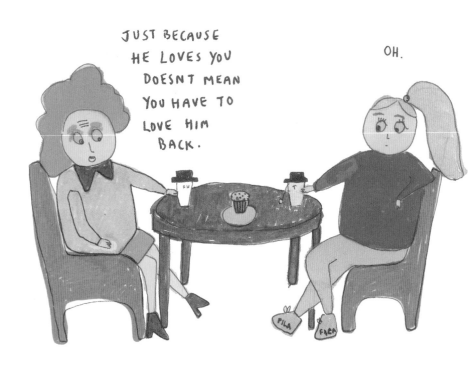

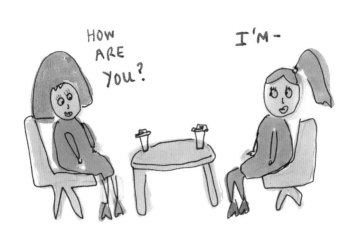

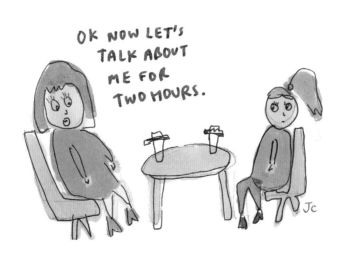

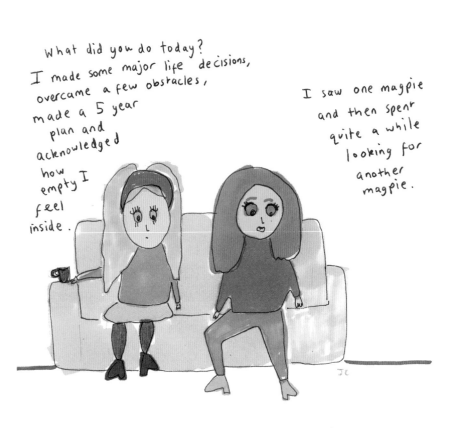

What did you do today?
I made some major life decisions, overcame a few obstacles, made a 5 year plan and acknowledged how empty I feel inside.

I saw one magpie and then spent quite a while looking for another magpie.

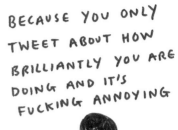

I THOUGHT WE WERE FRIENDS WHY DID YOU UNFOLLOW ME ON TWITTER?

BECAUSE YOU ONLY TWEET ABOUT HOW BRILLIANTLY YOU ARE DOING AND IT'S FUCKING ANNOYING

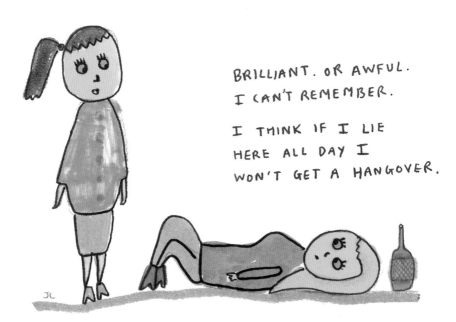

WE NEVER
HANG OUT
ANYMORE

THAT'S BECAUSE I'M
REALLY HAPPY AT
THE MOMENT AND
IT'S BETTER TO SEE
YOU WHEN I'M
DEPRESSED BECAUSE
YOU ONLY SEE THE
BAD IN THINGS.

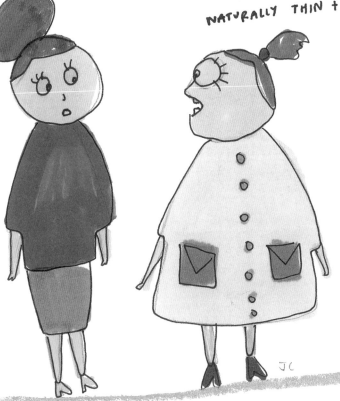

HOW DO YOU KNOW
IF YOU'RE IN LOVE?

YOU JUST
KNOW

BUT I DON'T KNOW

WELL YOU SHOULD
JUST KNOW

IT IS MY DUTY AS YOUR OLDER PRETTIER SISTER TO TEACH YOU WHAT NOT TO SAY IN TEXTS. I'VE DEVISED A 6 WEEK COURSE—

BUT WE'VE NOT FINISHED THE 'BE LESS DESPERATE' COURSE YET.

WHAT HAPPENED
TO YOUR
HAIR?

I WANTED YOU
TO HAVE A GO
AT BEING THE
MORE ATTRACTIVE
FRIEND FOR
A WHILE.

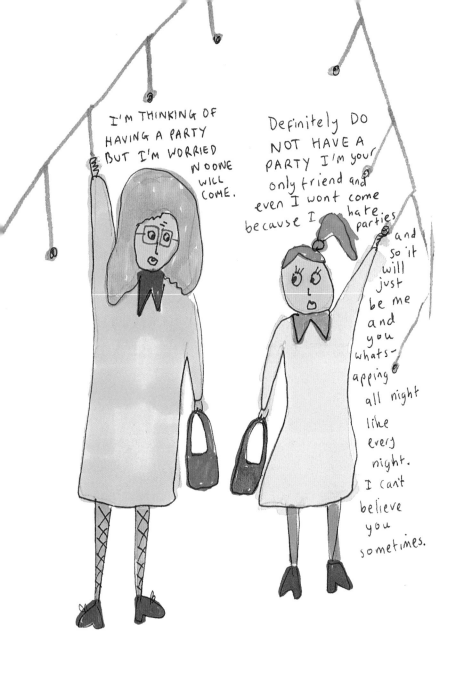

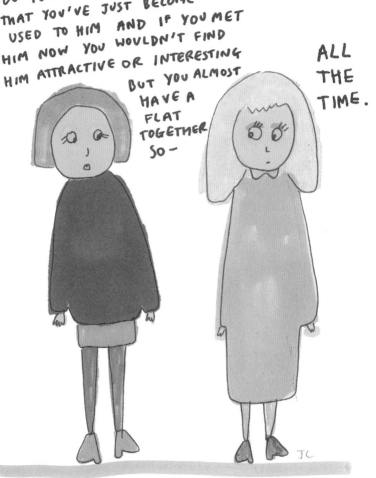

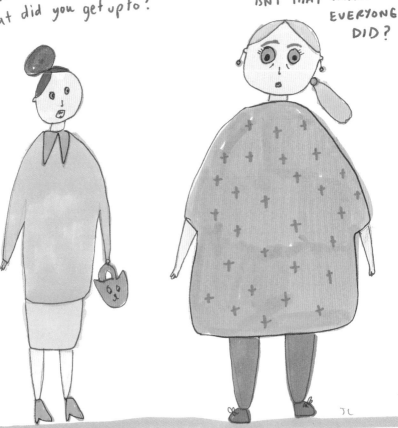

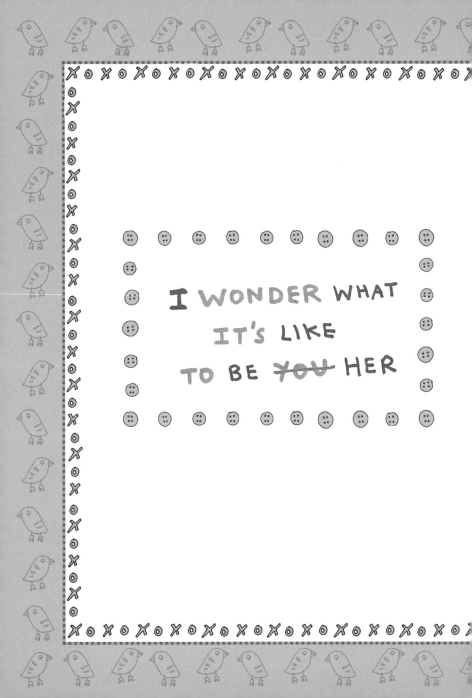

I WONDER WHAT IT'S LIKE TO BE ~~YOU~~ HER

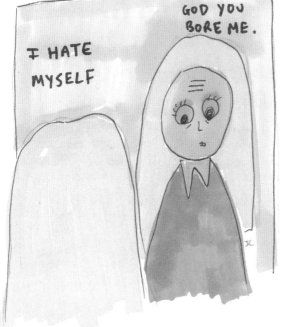

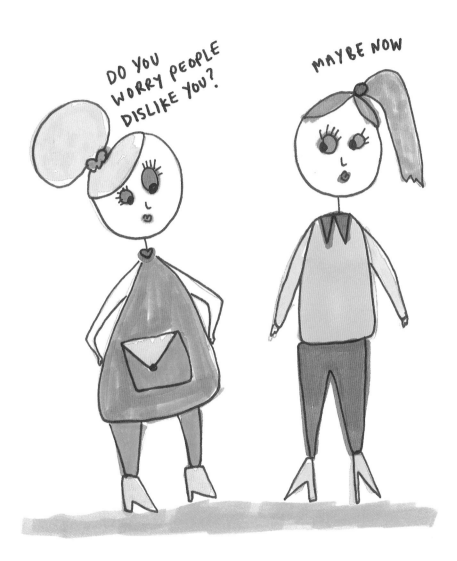

JANUARY 1ST

THIS YEAR I'M GOING TO ACCOMPLISH ALL
MY GOALS READ 20 PAGES EVERYDAY
RUN 5 MILES EVERY TWO DAYS WEAR A
DIFFERENT OUTFIT BE MORE PROACTIVE MORE
ADVENTUROUS BE
MORE GRATEFUL
BE MORE LOVING
BE BETTER AT
CROSSWORDS AND
SUDUKO AND
BEING RADIANT
LISTEN TO MORE
PODCASTS ABOUT
BORING THINGS
WATCH MORE
DOCUMENTARIES
ABOUT BORING
BUT EDUCATIONAL
SHIT EAT LESS CRAP
BE NICER WATCH LESS
NETFLIX LOVE MY
BODY BE MORE PRETTY
AND ASSERTIVE AND —

JANUARY 4th

I THINK I'VE SEEN THIS EPISODE

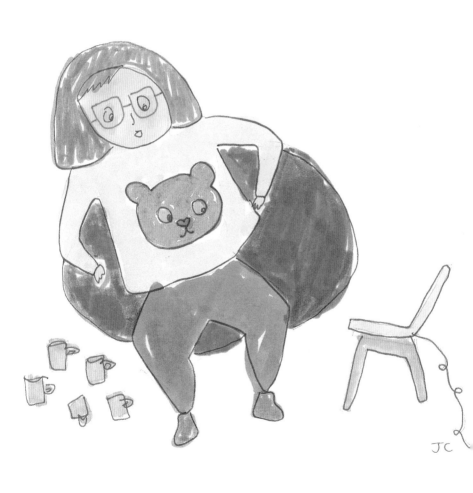

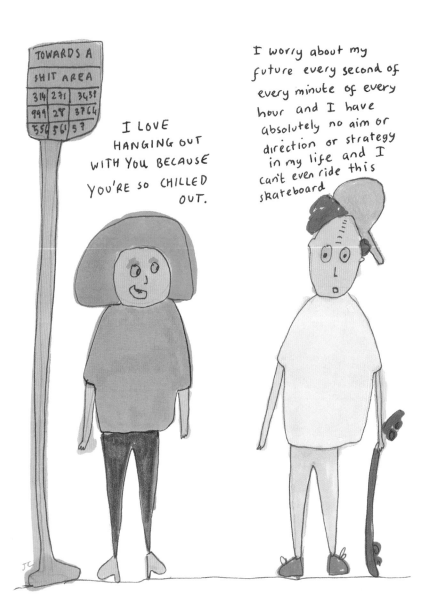

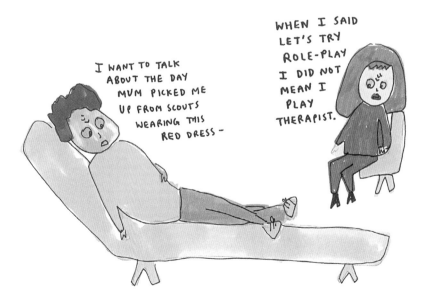

IS EVERYTHING OKAY?
YOU'VE BEEN INSIDE FOR TWO
DAYS LISTENING TO THE LION KING
SOUNDTRACK

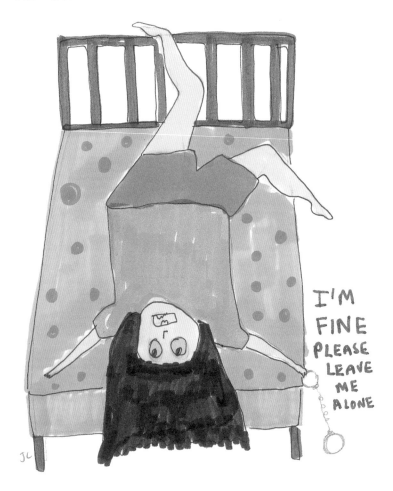

I'M
FINE
PLEASE
LEAVE
ME
ALONE

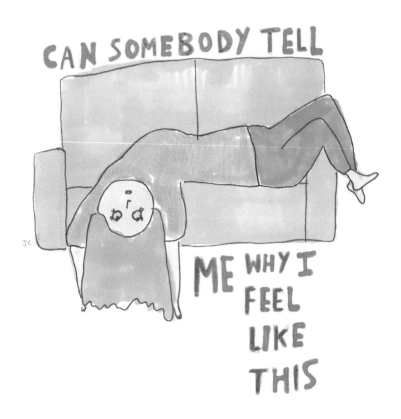

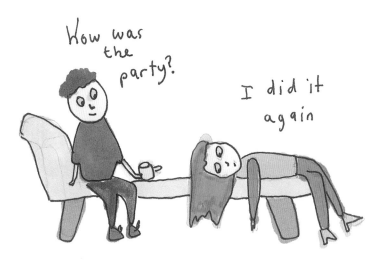

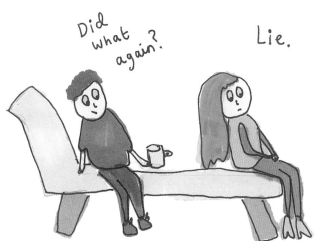

TODAY I'VE WATCHED 6 HOURS
OF COOKING PROGRAMMES AND
ORDERED A BOOK ON FULFILLING
YOUR POTENTIAL ON AMAZON.

□ □ □ □ □ □ □ □ □ □

I HAVE NO RECOLLECTION
OF THE 17 TEXTS
AND 2 VIDEOS I
SENT TO HIM LAST NIGHT.

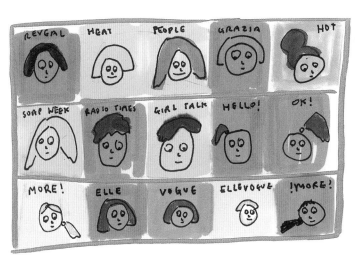

WHAT THE
FUCK AM
I SUPPOSED
TO BE

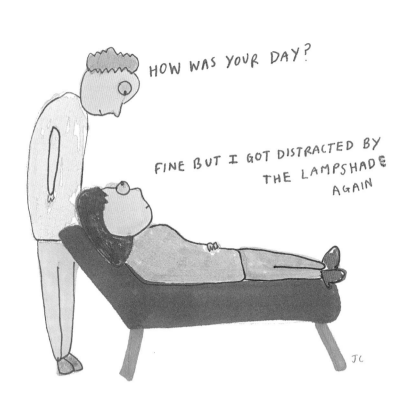

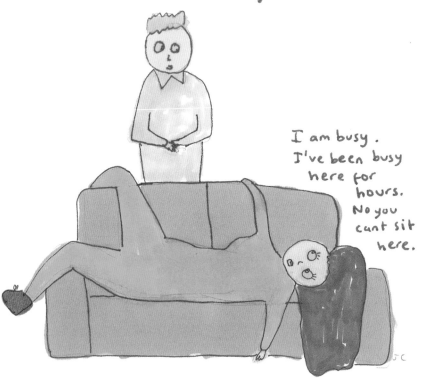

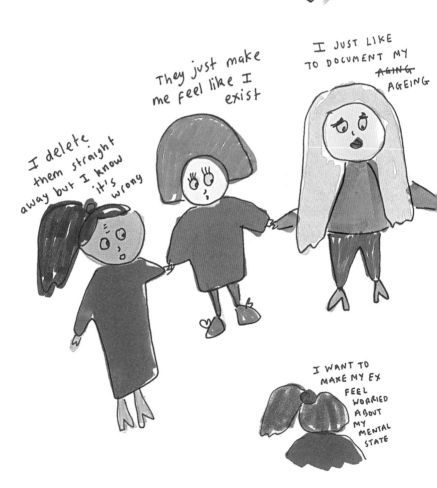

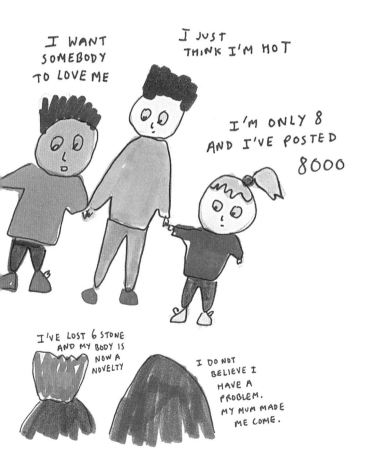

I THINK
I'M
DYING

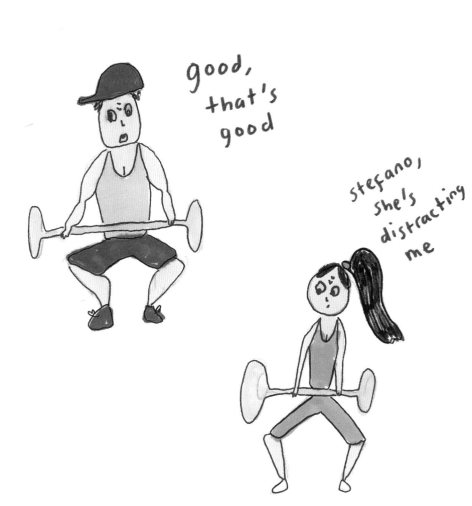

he's probably not googling me as much

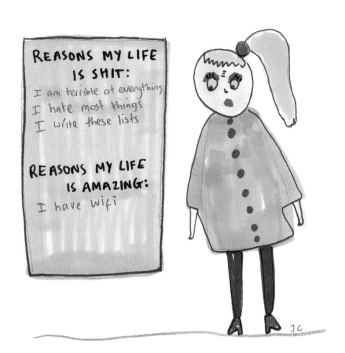

WHILE I WAS PROCRASTINATING I CONSUMED:

6 APPLES 3 SATSUMAS 4 GRAPES 2 DATES
 PACK OF RYVITA ?
 3 CRUNCHY NUT CORNFLAKES.
 2 FROSTIES.
 1 BANANA 17 RAISENS
 BUTTERSCOTCH
ANGEL DELIGHT 7 COFFEES
 OREOS. PEANUT BUTTER.
SHITLOADS OF SEESTNUTS
PACK OF GINGERNUTS
PACK OF CRUNCHY NUT
 ~~CORNEL~~ CORNFLAKES
 ↑ YES A ↑
 (WHOLE PACK) LOTS OF MILK
MARSBAR ?
TWIX MILKY WAY X 3
SNICKERS ?
MILK 3 MORE COFFEES
 ↑
DIET SPRITE DECAF
ANOTHER TWIX? MELON
 SKITTLES GELATO
OMLETTE . BACON . SYRUP ?
BREAD . FUCKLOADS OF
 BREAD. SHIT
 THEN I FELL ASLEEP AND
COULDN'T DO ANYTHING.

JC

WHAT DID I THINK ABOUT BEFORE
I THOUGHT ABOUT HIM ALL
THE TIME ?

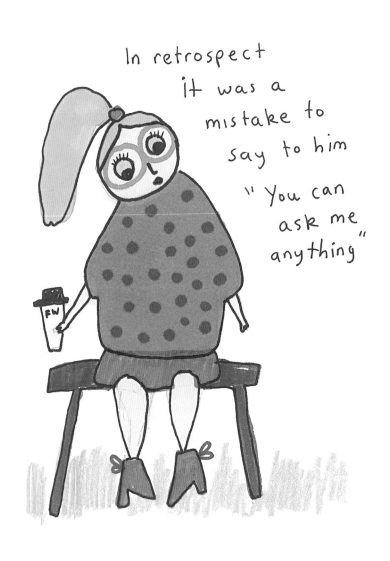

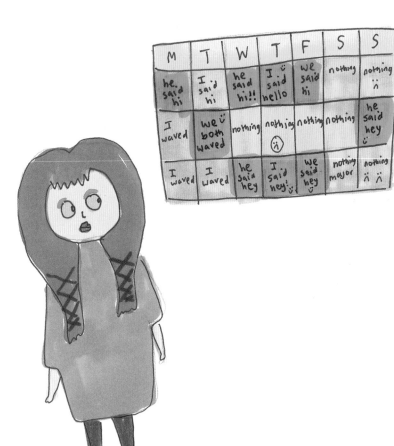

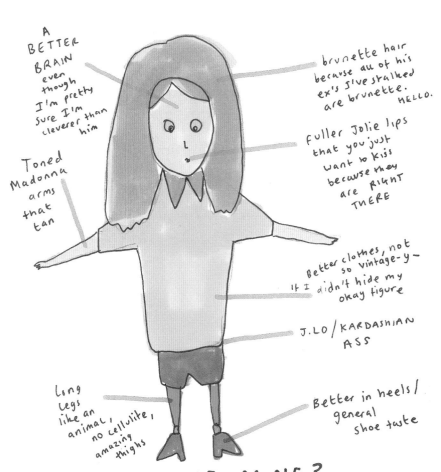

THE ONE I HAVE

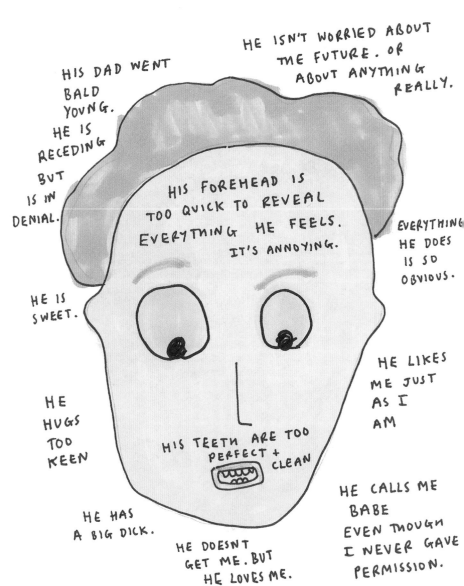

HE ISN'T WORRIED ABOUT THE FUTURE. OR ABOUT ANYTHING REALLY.

HIS DAD WENT BALD YOUNG. HE IS RECEDING BUT IS IN DENIAL.

HIS FOREHEAD IS TOO QUICK TO REVEAL EVERYTHING HE FEELS. IT'S ANNOYING.

EVERYTHING HE DOES IS SO OBVIOUS.

HE IS SWEET.

HE LIKES ME JUST AS I AM

HE HUGS TOO KEEN

HIS TEETH ARE TOO PERFECT + CLEAN

HE CALLS ME BABE EVEN THOUGH I NEVER GAVE PERMISSION.

HE HAS A BIG DICK.

HE DOESN'T GET ME. BUT HE LOVES ME.

THE ONE I CANNOT GET

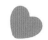

AMBIVALENTLY
EVER AFTER

YOU ARE BEING
QUITE MEAN,
BITCHY AND
COLD.
WHAT'S WRONG?

I'M EITHER
FALLING IN LOVE
OR I'M GETTING
THE FLU

I LIKE
YOU JUST
AS YOU ARE

I LIKE YOU JUST
AS YOU ARE TOO BUT
SLOWLY AND
SUBCONSCIOUSLY I
WILL CHANGE EVERY
LITTLE THING ABOUT
YOU

YOUR SURPRISE CHRISTMAS PRESENT IS A ROMANTIC WEEKEND AWAY IN PARIS!

BUT I TOLD YOU I WANTED A FURBY.

FUCK THIS.

SO NOW YOU'VE MET
ALL 88 VERSIONS OF
MYSELF, WHICH ONE
WOULD YOU LIKE ME
TO BE?

I THINK YOU
SHOULD APPLY SOME
OF YOUR WHATS$APP
PERSONALITY TO YOUR
ACTUAL FACE TO FACE
PERSONALITY

I'LL TRY

This weather is incredible! Imagine having a wedding today

yeah

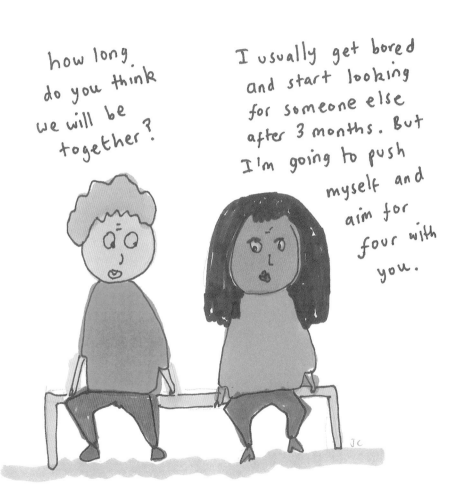

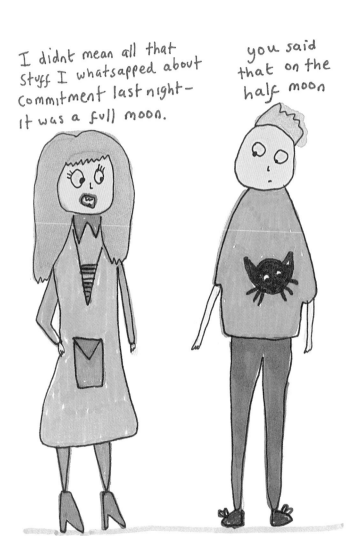

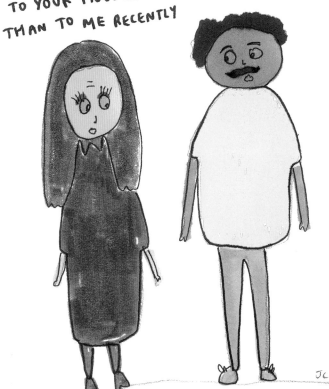

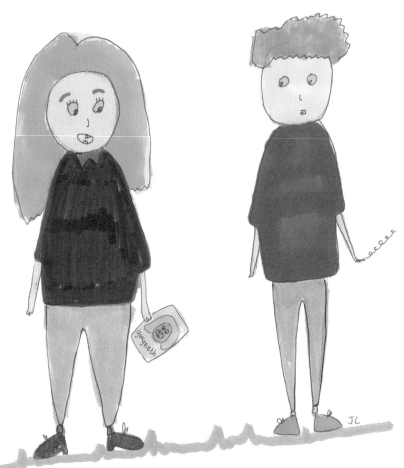

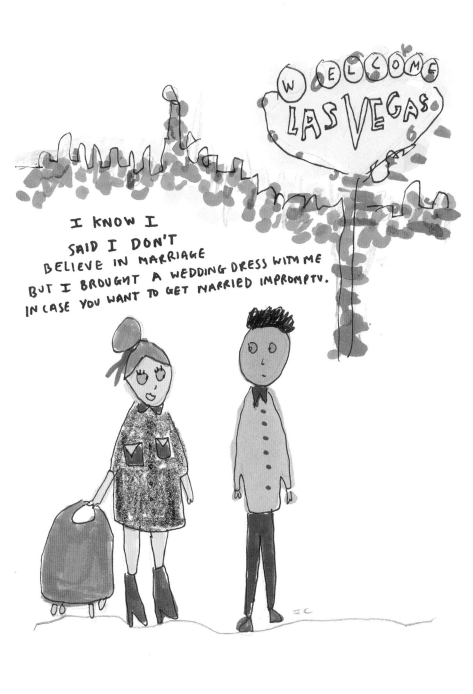

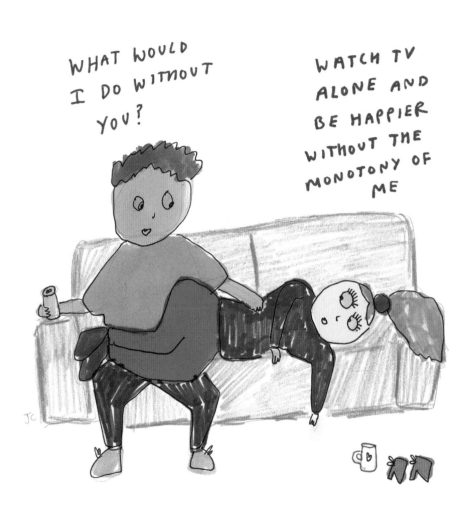

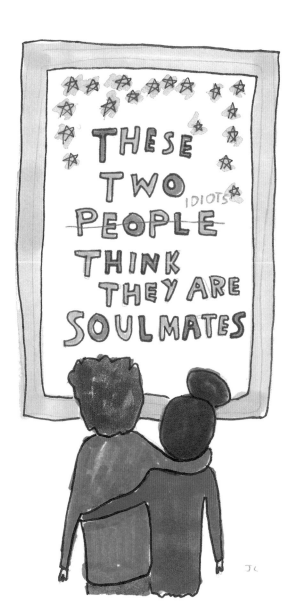

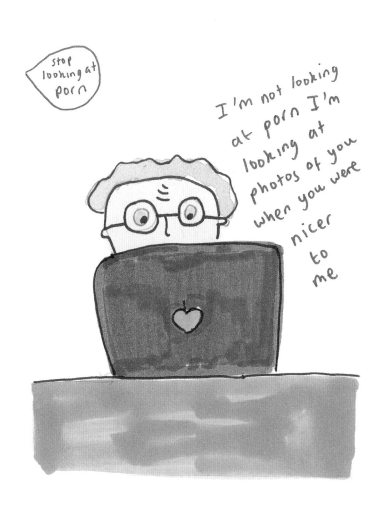

I CANT BELIEVE WE'VE HAD TO
HIRE A BUILDER. MY EX MICHAEL
DID ALL THE BUILDING + DECORATING BUT
STILL HAD TIME TO DO HIS FREELANCE STUFF
LIKE WRITING + WINNING
AWARDS

BBCD NEWS:
NOTHING IS EVER AS GOOD
AS YOU WANT IT TO BE

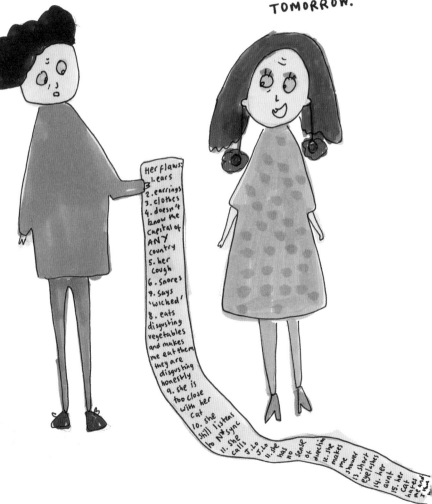

YOU FAILED
THE TRUST EXERCISE

BUT I
WASN'T
READY

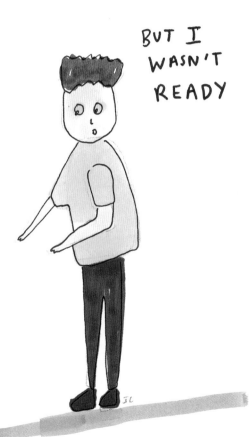

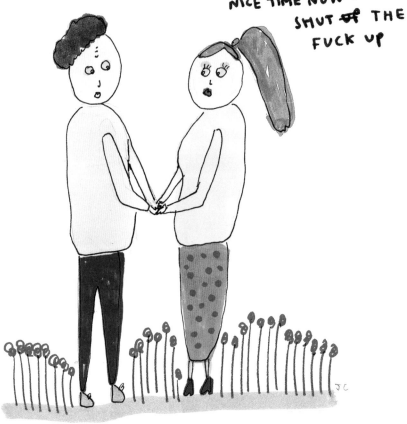

HERE

WE

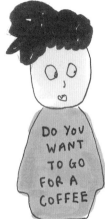

DO YOU
WANT
TO GO
FOR A
COFFEE

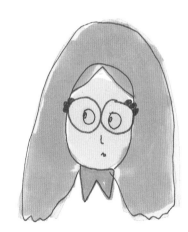

GO

AGAIN

10 9 8 7 6 5 4 3 2 1

Ebury Press, an imprint of Ebury Publishing,
20 Vauxhall Bridge Road,
London, SW1V 2SA

Ebury Press is part of the Penguin Random House group of companies whose
addresses can be found at global.penguinrandomhouse.com

Illustrations © Jessie Cave 2015

Jessie Cave has asserted her right to be identified as the author of this Work
in accordance with the Copyright, Designs and Patents Act 1988

First published by Ebury Press in 2015

www.eburypublishing.co.uk

A CIP catalogue record for this book is available from the British Library

9781785031205

Colour origination by Altaimage Ltd, London
Printed and bound in Italy by Printer Trento S.r.l.

Penguin Random House is committed to a sustainable future for
our business, our readers and our planet. This book is made from
Forest Stewardship Council® certified paper.